28 Paradises

David Zwirner Books

ekphrasis

28 Paradises
Patrick Modiano and Dominique Zehrfuss

Translated by Damion Searls

Contents

Another Life

Damion Searls

Dominique Zehrfuss's childhood paradise was someone else's. It looked, from the outside, incomparably glamorous: her mother, Simone, was a beautiful Tunisian Jew; her father, Bernard, was a renowned architect who would become famous for designing the UNESCO building in Paris. Their love affair was the stuff of legend.

Simone, in her teens, had married an older, wealthy adventurer, and when, barely twenty, she consulted a lawyer about leaving her husband, the lawyer fell in love with her, too, and soon became her even older second husband. She had parleyed walking out on her marriage into becoming "the most respected woman in Tunis," a kind of hero among the local high society for having deserted a rich Tunisian businessman in favor of an upstanding French lawyer. Her beauty had earned her the nickname "the black pearl of the Sahel."

Bernard Zehrfuss had led nearly as spectacular a life—winning the Grand Prix de Rome as an architect, joining Charles de Gaulle in Algeria during the war, and becoming one of Consuelo de Saint-Exupéry's lovers. He married the widow of a spahi officer with whom he'd had a brief affair while her first husband was still alive; when Mrs. Zehrfuss was away, Consuelo came to Tunisia to try to win Bernard back. Later, Antoine de Saint-Exupéry, before his mysterious disappearance, came to meet "the man my wife loves"; they became friends.

Finally, one late afternoon in 1945, Simone and Bernard met in Hammamet. As Dominique would write in her 2010 memoir: "My mother was dressed in gray,

wearing two white camellias in her jet-black hair, and she asked my father if he might drive her horse-drawn carriage back to the village."[1] After a passionate, secret four-year affair, Simone left her second husband and their eleven-year-old daughter in Tunisia and went to Paris with Bernard. When the divorce came through, she and Bernard were married; nine months later to the day, Dominique was born.

All very dramatic. Her parents always told her—in her memoir, Dominique puts it in all capital letters—"YOU ARE THE CHILD OF A TRUE LOVE." But Simone was as dominating and depressive as she was dashing. Dominique was raised by a series of nurses and nannies, never feeling she was at the center of her parents' life. Simone's reaction to her birth, Dominique relates, was that "she so wished she had given a son to the man she loved. A strange way to acknowledge my existence." Zehrfuss gave her memoir the title *Peau de caniche*, literally "A Poodle's Skin," but "poodle" in French implies something more like the English "lapdog" or "show pony"— an accessory trotted out as entertainment. Dominique does not remember seeing her parents when she was with other children, only when with adults. She felt like a party trick; at one point she calls herself "a robot"; she was not even a poodle, just something invisible under its skin. The paradise was never hers.

In the last sentence of her memoir, she says it was thanks to a man she met as she emerged from this childhood "that I was able to leave my poodle rags behind and

gradually turn into a human being." That man became her husband: Patrick Modiano.

The story of Modiano's childhood and later life has been told many times—in articles published after he was awarded the Nobel Prize in Literature in 2014; in translators' introductions to his books, especially the loose trilogy *Suspended Sentences*; and in Modiano's own memoir, published five years before *Peau de caniche* and also centered around a canine self-depiction: *Pedigree*, in which he calls himself a dog without one.[2] I will not summarize his life story here; besides, Modiano's work is one long act of using and combining the elements of that life into something else. What we're supposed to call real life, he writes in *28 Paradises*, has never been real to him.

The twenty-eight miniature paintings in this book, he says, were painted by "The Lilliputian." In another life, in the sixties, Modiano had written pop songs for Françoise Hardy, among others; in 1979, Hughes de Courson put out an album of three instrumentals and nine songs with lyrics by his friend Modiano, called *Bottom of the Drawer [1967]*—songs from that other time. Modiano's liner notes explain:

Everything ends up in drawers. You just have to open them to find again the lost years, with the dried flowers, the yellowed photographs, and the songs. Someone has said that the best way to relive the passed

moments are scents and songs. What are the scents of 1967? I don't know, but in the meantime I found in the bottom of a drawer a few songs that Hughes de Courson and I wrote in this particular year.

The album's cover photograph depicts one such drawer where everything ends up. And one of these songs was *Ma Liliputienne* (My Lilliputian), based on the true story of a very short prostitute, installed in a Paris brothel for high-ranking members of the Vichy government, in a low-ceilinged apartment complete with miniature furniture.[3]

Is this the same Lilliputian who "painted her paradises," whom the narrator of the prose poem knows so well—who in real life is Modiano's wife, Dominique Zehrfuss? It is and it isn't. Real life has never been real. For that matter, some of the songs from *Bottom of the Drawer [1967]* weren't written until 1979. The scent of the past, the bottom of the drawer, is all fiction, or dream.

"In another time," Modiano writes elsewhere in *28 Paradises*, "Another life / I was in Paris / On impasse du Doyenné." He is no more Patrick Modiano, born 1945, than he is Gérard de Nerval (1808–1855), the writer who lived at 3 impasse du Doyenné in 1834 and famously wrote in *Aurélia* that dreams are another life. Like Nerval, the narrator here "held dances and threw dinner parties / And invited the cydalises and the bousingots"—respectively, young women of the mid-nineteenth century to whom Nerval wrote a poem, "Les Cydalises" ("Where are our

lovers? They are in the grave"), and French literary and political rebels from the early 1830s.[4]

Nerval is the subject of one of Modiano's finest essays, in which he calls him

> the guide we follow on all his roaming through the streets, the neighborhoods, the country roads and paths. He is not simply moving through space—he, too, though more delicately than Proust, sets off in search of lost time.
>
> I was wrong, in fact, to use the word "guide" just now: it does not in the least apply to Nerval. He never wants to impose anything on us; he never looks down on us or tries to impress us. He is the most gentle writer in French literature, if one takes the word *gentil* in its etymological sense: nobility of heart.[5]

In all these ways, the prose of *28 Paradises* is beautifully Nervalian—gentle, haunting, unassuming. Walks turn into dreams; dreams turn into walks, and returns; pictures turn into poems.

Dominique recalled her wedding day, September 12, 1970, as "a disaster. It was raining. Our witnesses were Raymond Queneau, who had taken Patrick under his wing when he was a teenager, and André Malraux, a friend of my father's. They started arguing about Jean Dubuffet and we were standing there like we were watching a tennis match! That said, it would be nice to have

photographs, but the only person who'd brought a camera forgot the film. So all we have is one photo, from behind and under an umbrella."[6]

Modiano, for his part, has dedicated several novels to his wife but has rarely written about her directly. The closest thing to a description of their marriage, I believe, comes in the opening pages of his 1981 novel *Young Once*, with Louis and Odile in the mountains, about to turn thirty-five.[7] Patrick and Dominique collaborated on two books in the 1980s, children's books once again filtering the authors' experiences through a dog's life, in this case a white Labrador named Choura who is unhappy in his Parisian family and school, leaves for a glamorous life on the Riviera with Baroness Orczy (author of *The Scarlet Pimpernel*), and then goes on to further adventures.[8]

Almost twenty years later came *28 Paradises*.[9] "One summer," Zehrfuss wrote, "when I was sad in Paris, I couldn't see any way out of my melancholy except by dreaming. To bring these reveries to life, I started drawing minuscule worlds, earthly paradises, lost paradises, where I imagined myself with what I loved; where we were countless particles of a mineral and vegetal world—that of the leaves, the stars, the grains of sand ... When one '*se fait tout petit*,' 'makes oneself small or inconspicuous,' one can disappear, but maybe we do it to be reborn all the better in another world, a Garden of Eden."[10]

1 Dominique Zehrfuss, *Peau de caniche* (Paris: Mercure de France, 2010).
 Much of the biographical information in the present introduction is
 quoted or, since it is not otherwise available in English, paraphrased
 from this memoir.

2 Mark Polizzotti, introduction to *Suspended Sentences*, by Patrick Mo-
 diano, trans. Mark Polizzotti (New Haven: Yale University Press, 2014);
 Patrick Modiano, *Un pedigree* (Paris: Gallimard, 2005); translated by
 Mark Polizzotti as *Pedigree* (New Haven: Yale University Press, 2015).
 Zehrfuss, too, refers to Modiano as "another lost dog without a collar,"
 in the last sentence of *Peau de caniche*.

3 Peter De Jonge, "The Notes of Patrick Modiano," *Harper's Magazine* (Jan-
 uary 2017). Details about the album—*Fonds de tiroir [1967]* in the original
 French—and the quote from the liner notes are also from this article.

4 On the latter, see John Emerson, "Bousingot Not in Your Dictionaries,"
 accessed May 2018, haquelebac.wordpress.com/2010/03/07/bousingot
 -not-in-your-dictionaries.

5 Patrick Modiano, "Gérard, de la rue des Bons-Enfants," *Le Monde*, July 2,
 2004. My translation.

6 Dominique Zehrfuss, interview, *Elle*, October 6, 2003. Quoted in *Le Ré-
 seau Modiano*, http://lereseaumodiano.blogspot.com/2011/11/dominique
 -zehrfuss-patrick-modiano.html.

7 Patrick Modiano, *Une jeunesse* (Paris: Gallimard, 1981); translated by
 Damion Searls as *Young Once* (New York: New York Review Books, 2016).

8 Patrick Modiano and Dominique Zehrfuss, *Une aventure de Choura* (Paris:
 Gallimard, 1986) and *Une fiancée pour Choura* (Paris: Gallimard, 1987).

9 Dominique Zehrfuss and Patrick Modiano, *28 Paradis* (Paris: Éditions
 de l'Olivier, 2005); republished by Gallimard in 2012 with a sequel,
 28 Enfers (28 Hells), consisting of art by Zehrfuss and text by her younger
 daughter, Marie Modiano.

10 Patrick Modiano and Dominique Zehrfuss, *28 Paradis, 28 Enfers*. My
 translation.

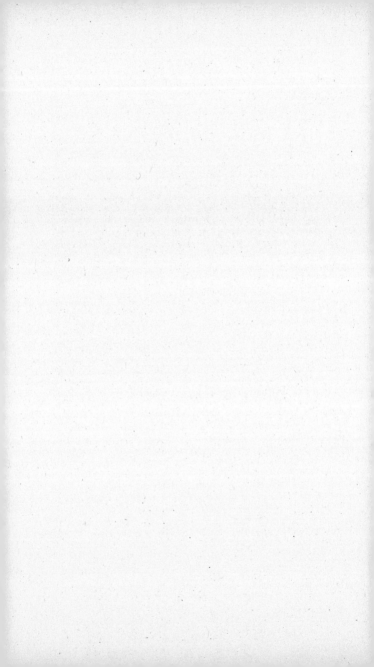

28 Paradises

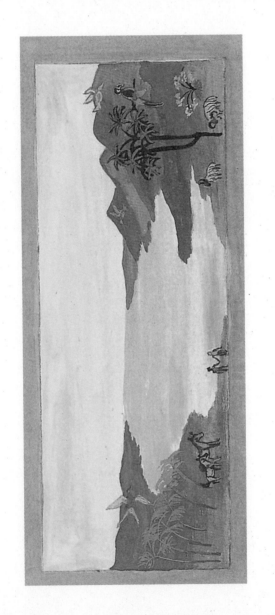

I was in a small town

Near the border far to the east or maybe even farther

At the edge of the countries named for the snow and the moon

I was staying in a room at the Inn of the Golden Bear

In the evening I took a walk

Down the deserted street to the station

Outside of which a carriage was waiting harnessed to a white horse

But with no coachman

There was no one in the square

The station was closed

In the silence I asked

If the express train was coming at nine o'clock

Like every night

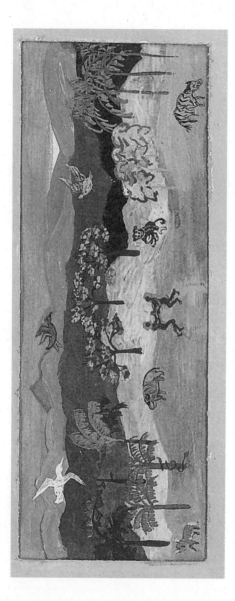

And I dreamed of paradises
I shut my eyes and saw pass before me
The chariot pulled by swans

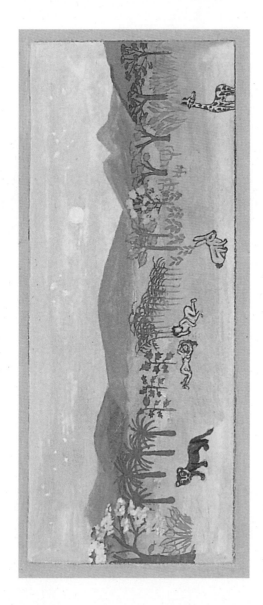

I found once more
The elephant and the snail
The cerberus and the centaur

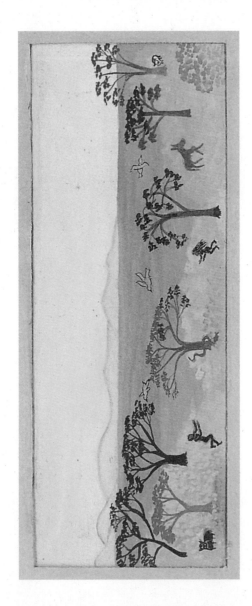

The ibis and the alligator
The hummingbirds
Under the turquoise-colored sky

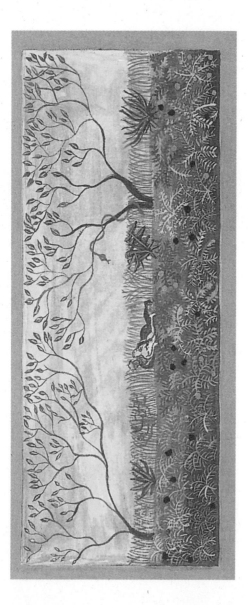

And the roses growing without thorns

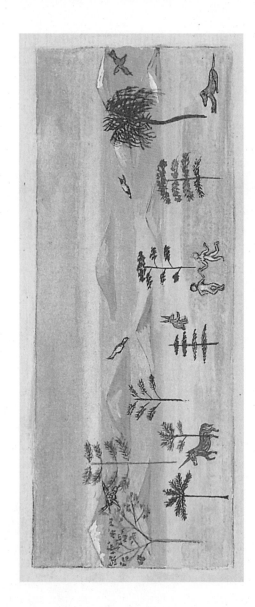

In that small town on a distant border
I arrived at the end of myself

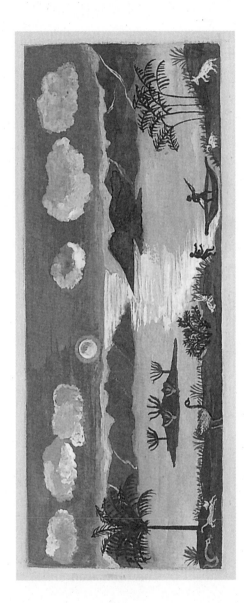

I had lived my life
I no longer cared about the past
Even less about the future

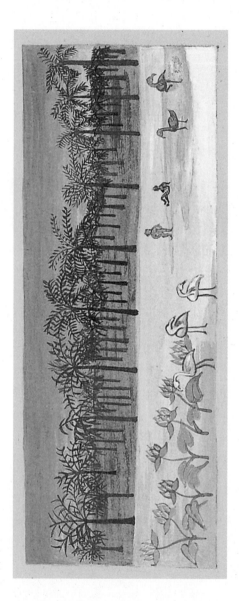

Once long ago
I had been a bad student
A stubborn and shifty child
Who dreamed of paradise

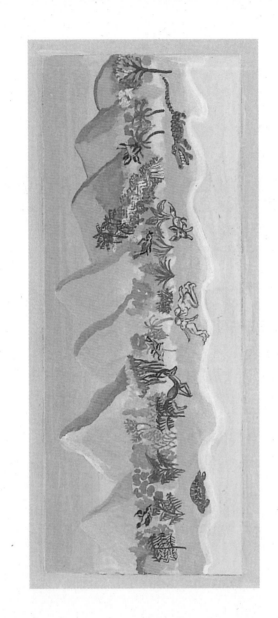

The grand boulevard of palm trees
Led to the cloakroom of the angels

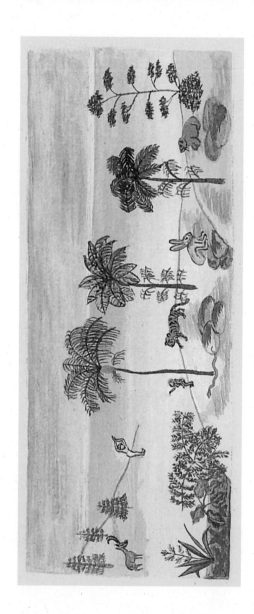

I wondered
What there was for the animals to graze on
Wild strawberries or bell heather

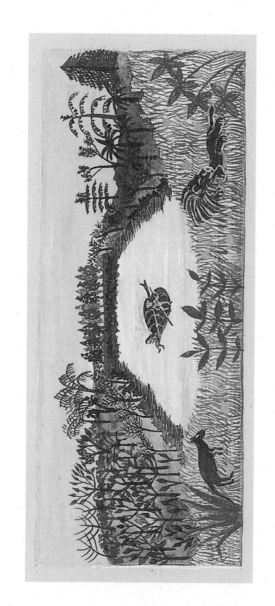

And I counted along the boulevard
A dozen lily of the valley stems
A dozen goldenstars

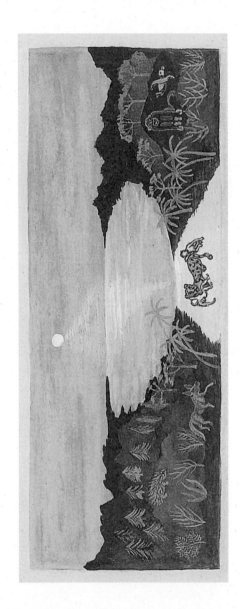

Meet me at the lakeshore
At sunrise
You will find once more what you've lost

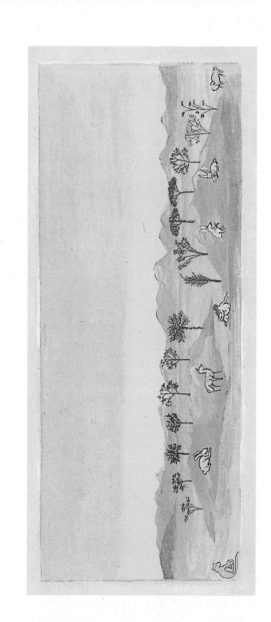

In the café at the tables next to mine
The customers were playing cards and chess
I was not playing anything
If I had known that in the distant future
The days and nights would be so long
I would have learned to play games with other people

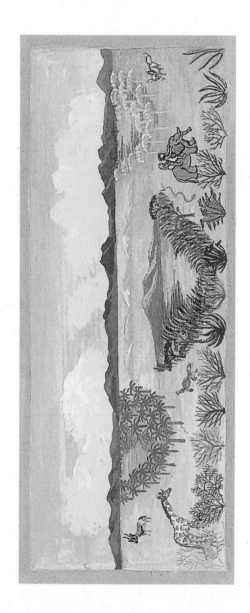

To pass the time
I dreamed of paradises

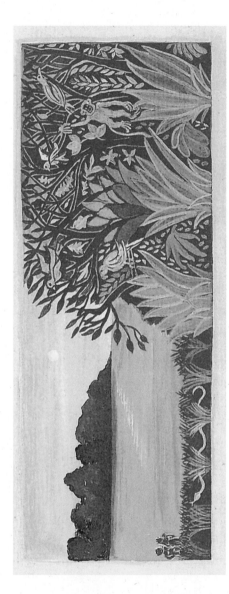

A voice murmured in my ear
Look down there
The castle and the waterfall
If you cross the field
You will hear
The musics of silence

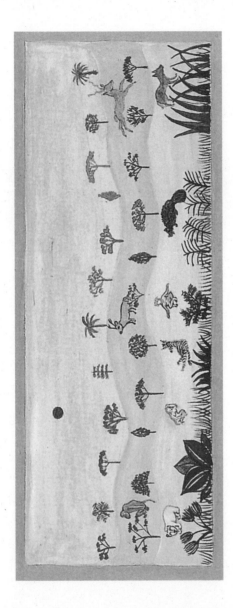

And you will understand that the sirens

Are much more beautiful

When they do not sing

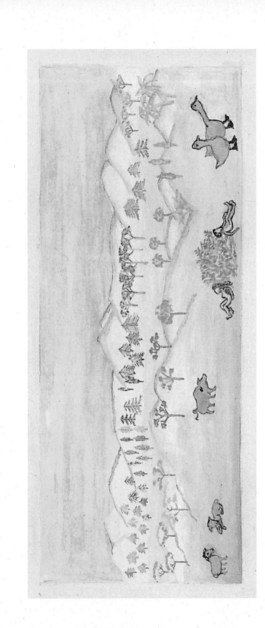

Right at the edge of town behind the barracks
On a sloping street which smelled of privet
Mr. Georges Karagoslou's antiques store
Was open only on Tuesdays and Thursdays
Between three and five in the afternoon
I went there often
I don't think Mr. Karagoslou had many other customers

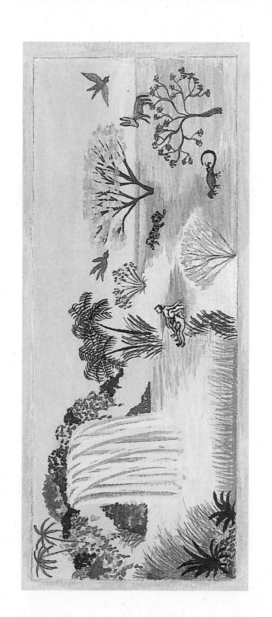

In the back of the store I discovered
Twenty-eight tiny paintings
Of skies and meadows in gentle colors
Where animals ran free

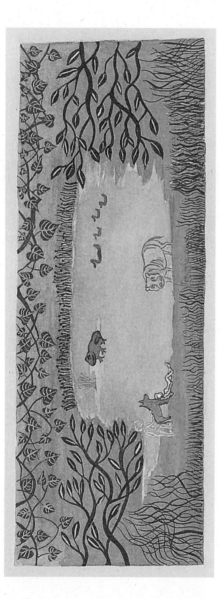

I looked at them one after the other
So hard that I entered into every painting

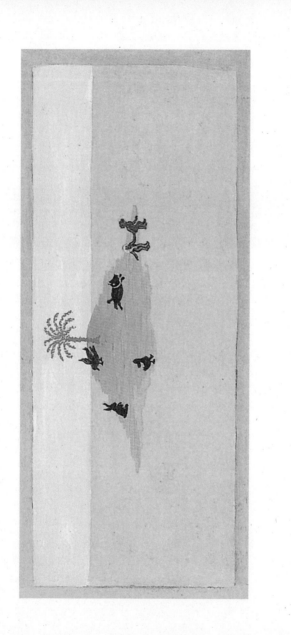

Without knowing if I would ever return
To what we're supposed to call
Real life
But it's never been real to me

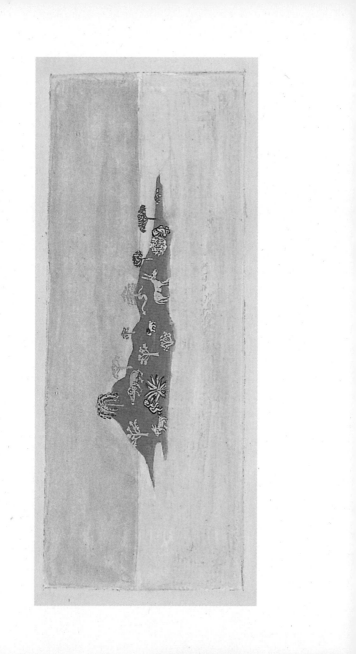

These are twenty-eight images of paradise the antiquarian said to me

Which a traveler sold to me

He spent a day in our town

Before crossing the border

They were painted a long time ago

By a woman who signed her name "The Lilliputian"

I didn't say anything
But he was telling me my own story

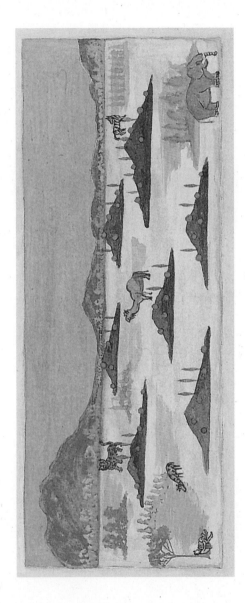

The Lilliputian
I knew her well
For a moment I felt I was about to cry
In a calm indifferent voice
I told him
I'll buy your paintings

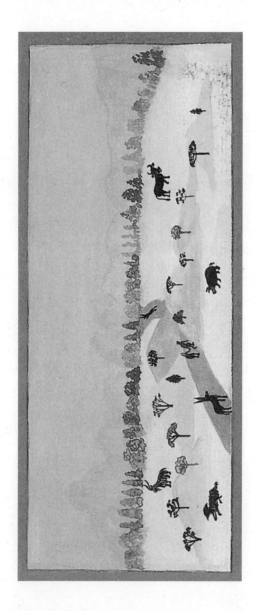

When I left the store
And walked down the street of privet
I thought that memories are not for sale
My paradises under my arm
I hung them up on the walls of my room at the Golden Bear

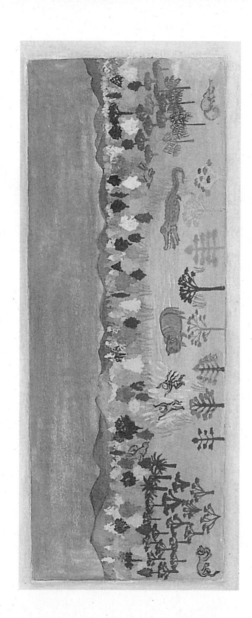

We came to the lull of autumn
When the days grow shorter
But it was enough to look at the twenty-eight paradises
For the light of bygone summers
To come into my room
Through the Persian blinds

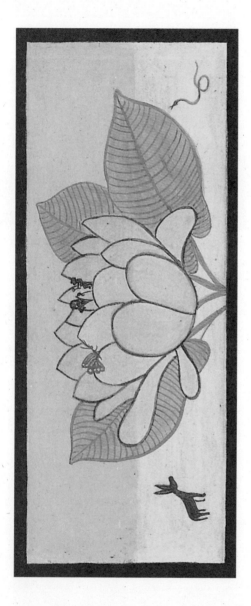

In another time
Another life
I was in Paris
On impasse du Doyenné

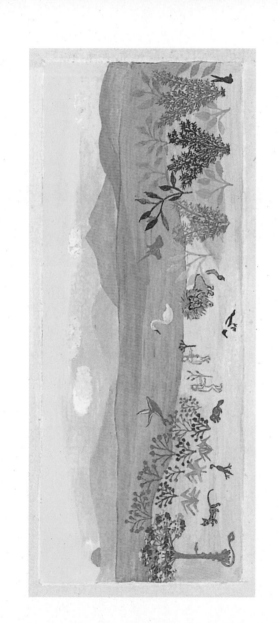

At night in the studio
We held dances and threw dinner parties
And invited the cydalises and the bousingots
People danced until dawn
Balancing
On the hammock of Sarah la Blonde

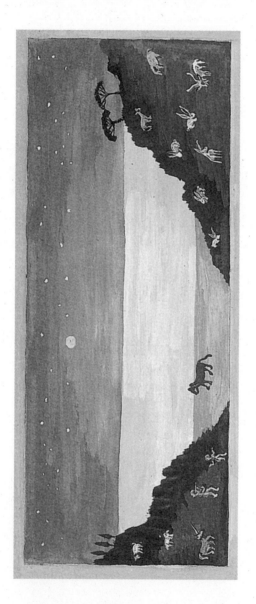

The large window looked out over the carousel of the king's stables

And onto the clock always showing the same time

That of youth and eternal noon

During the day

The Lilliputian painted her paradises

And I

Next to her

Wrote a poem

PATRICK MODIANO spent his childhood between Paris, Haute-Savoie, and Jouy-en-Josas. Having been awarded his baccalaureate, he dedicated himself to literature at the age of eighteen. It was Raymond Queneau who introduced to him in the 1960s the literary circles of Paris. He won the Grand Prix du roman de l'Académie française in 1972 and the Prix Goncourt in 1978. In 2014, his oeuvre was crowned with the Nobel Prize in Literature.

DOMINIQUE ZEHRFUSS is an illustrator and a jewelry designer living in Paris. After studying architecture at École des Beaux-Arts in Paris, she began to paint. Quickly, however, the illustration of children's books took over her imagination. She and Patrick Modiano have collaborated on three books, *Une aventure de Choura* (1986), *Une fiancée pour Choura* (1987), and *28 Paradis* (2005). In 2017, her book with Marie N'Diaye, *28 bêtes: un chant d'amour*, was published by Editions Gallimard.

DAMION SEARLS is an American translator and writer. He has translated forty books from German, French, Norwegian, and Dutch, including Patrick Modiano's novels *Young Once*, in 2016, and *Sundays in August*, in 2017. David Zwirner Books's *ekphrasis* series also includes his translation of Rainer Maria Rilke's *Letters to a Young Painter* (2017). His own writing has been translated into ten languages.

THE *EKPHRASIS* SERIES

"Ekphrasis" is traditionally defined as the literary representation of a work of visual art. One of the oldest forms of writing, it originated in ancient Greece, where it referred to the practice and skill of presenting artworks through vivid, highly detailed accounts. Today, "ekphrasis" is more openly interpreted as one art form, whether it be writing, visual art, music, or film, that is used to define and describe another art form, in order to bring to an audience the experiential and visceral impact of the subject.

The *ekphrasis* series from David Zwirner Books is dedicated to publishing rare, out-of-print, and newly commissioned texts as accessible paperback volumes. It is part of David Zwirner Books's ongoing effort to publish new and surprising pieces of writing on visual culture.

OTHER TITLES IN THE *EKPHRASIS* SERIES

FORTHCOMING IN 2019

28 Paradises
Patrick Modiano and
Dominique Zehrfuss

Translated from the French
28 Paradis

Published by
David Zwirner Books
529 West 20th Street, 2nd Floor
New York, New York 10011
+ 1 212 727 2070
davidzwirnerbooks.com

Editor: Lucas Zwirner
Translator: Damion Searls
Project Manager: Elizabeth Gordon
Proofreader: Chris Peterson

Design: Michael Dyer / Remake
Production Manager: Jules Thomson
Production Assistant:
Elizabeth Koehler
Color separations: VeronaLibri,
Verona
Printing: VeronaLibri, Verona

Typeface: Arnhem
Paper: Holmen Book Cream,
80 gsm

Publication © 2019
David Zwirner Books

Translation and Introduction
© 2019 Damion Searls

All art © 2005 Dominique Zehrfuss

Distributed in the United States
and Canada by
Simon & Schuster, Inc.
1230 Avenue of the Americas
New York, New York 10020
simonandschuster.com

Distributed outside the
United States and Canada by
Thames & Hudson, Ltd.
181A High Holborn
London WC1V 7QX
thamesandhudson.com

ISBN 978-1-64423-002-2

Library of Congress
Control Number: 2019932881

David Zwirner Books

ekphrasis